CHANEL

PERFUME

© 2003 Assouline Publishing
601 West 26th Street, 18th floor
New York, NY 10001
USA
Tel.: 212 989-6810 Fax: 212 647-0005
www.assouline.com

Color separation : Gravor (Switzerland)
Printed by Grafiche Milani (Italy)

Translated from the French by Sandra Petch

ISBN 2 84323 517 0

CHANEL

PERFUME

FRANÇOISE AVELINE

ASSOULINE

t heir paths crossed in the Ritz dining-room. Nothing more. Mademoiselle Chanel and Marcel Proust, each engaged in their own personal battle with time. He desperately in search of lost time. She relentlessly blazing a trail into the future. And yet it was with elements from her own life story that Gabrielle Chanel was to fashion her times. She would impose a style built on reminiscences, signs and symbols, journeys and encounters: the style of a woman who resembled no other.

With the most precious essences in the world, with the most seductive and expressive faces, with forms and colors, artisans and artists, numbers

and words, Chanel fragrances tell of this intimate world. The pieces of a compelling puzzle, they relate what makes Chanel so unique: its identity. From the origins of N° 5 to the present-day compositions, the underlying inspiration is the same, the references reincarnations of themselves. Like so many variations on a theme, that of Gabrielle herself, the women's fragrances express a certain spirit of fashion and seduction. As most, whether through friendship, love or sometimes admiration.

Subtly orchestrated by today's fragrance creators, they hide other clues, associations, and secret affinities, and always a single, consistent style. Unique, inimitable. A discovery of beauty, luxury, and Chanel.

In the beginning was No. 5. More an overture than a flight of oratory. Opulence takes over, sensual and captivating, to suddenly vanish like a dream in the first light of morning, leaving behind a fragrant recollection of ylang-ylang, drenched in the sweltering heat of the Comoro Islands. We find ourselves suspended on this lingering abstract note, the mere suggestion of itself, a desire awakened that is still no more than a promise, a maneuver in the game of seduction. Its intentions grow clearer in a mixed bouquet, a floral explosion in which Centifolia rose and the fullness of jasmine come to the fore. Grandiflorum jasmine, the one and only, whose flowers must be caught unawares at the foot of the Esterel mountains before the sun harms their precious fragility. One also feels a hint of good style, the elegance of a heart that will surrender if treated with care. A need for beauty and harmony that is the sign of true femininity. The final note treads softly, secretly, the intimate scent of Mysore sandal and Bourbon vetiver. An emotion that continues to cast its spell, warm and sensual, an enchantment.

This is the 'woman's fragrance with a woman's scent,' created by Ernest Beaux in 1921 for the *couturière* whose name was on everyone's lips as the Roaring Twenties began. Like all her creations, it was a fragrance in her own image. This rich and complex perfume was the echo of the ultimate in femininity, that of the woman whom Georges Auric described as 'Beautiful, more than beautiful. Glorious.'

After revolutionizing the meaning of elegance in fashion, Mademoiselle decided that a woman's fragrance was an integral part of her style. To bring the ultimate finishing touch, she had to have a perfume ... but of course, not just any perfume. At the turn-of-the-century, the fashion was for heady mono-floral fragrances, 'iris, cypress, gardenia, rose, dubbed with ridiculous and pompous names intimating dubious Oriental blends, such as *Suave Orient*, *Spellbound* or *Virginity*.' (Pierre Galante – *Mademoiselle Chanel*). Chanel was set on finding a scent that would remind her of the soap she used as a child, and the beautiful Emilienne d'Alençon of whom Chanel would say, 'She smelled good, she smelled clean.' Grand-Duke Dimitri of Russia, back from a trip to Italy, introduced Mademoiselle to Ernest Beaux, an inspired creator and pioneer of modern perfumes. Born in Moscow to French parents, at 17 he had joined Rallet, the leading Russian perfume company and supplier to the Imperial court. Following the Revolution of 1917, he left Russia for Grasse, the 'fragrance capital' in the South of France. This is where Chanel met him. She immediately wanted to learn all there was to know about the alchemy of fragrance, the ingredients, their extraction and transformation. Enthralled, she listened to Ernest Beaux talk to her about aldehydes, powerful but unstable synthetic molecules that exalt aromatic scents. She told him of her project, and together they got down to work. In 1921, Ernest Beaux presented Chanel with two sets of numbered samples. She chose sample number 22, which she would launch a few months later, and immediately adopted sample number 5. More than a bouquet, it was an emanation! No fewer than eighty ingredients

entered into its composition –to which she added jasmine, lots of jasmine (such extravagance!)– intensified by the aldehydes. The fragrance marked a revolution, the start of a new era for perfume. 'A natural fragrance can only be the fruit of an elaboration, a construction of the mind,' she affirmed, thereby defending the paradox that in order to give off a natural scent, a perfume had to be man-made. This was a visionary remark as, while ingredients at that time were for the most part of natural origin, no modern-day perfumer could forgo the infinite variety of nuances that research has added to the olfactory palette.

t he extraordinary complexity of the No. 5 fragrance set it apart from all that had gone before, while the stunning simplicity of its name and bottle made others seem suddenly outdated. Just why Mademoiselle 'named' her perfume with a number is part of its mystery. No doubt because it was the fifth sample that Ernest Beaux proposed. Five is also a magical number, the alchemist's *quintessence* or 'fifth essence,' and Chanel's intimate number in numerology. It would always bring her luck.

She designed the bottle herself. Pure, austere even, its minimalism is that of a laboratory vial. It carries a no-nonsense label of simple black letters on a white background. Chanel dressed this precious, subtle feminine fragrance in a uniform then stamped it with a matriculation number … as though to exorcise the convent school pupil she had once been when, carefully concealed under her black smock, she already nurtured an inordinate taste for luxury and the sense of elegance that would put the world at her feet. For Chanel, the content would always be more important than the container. Sobriety, when used to promote the essential, was the guarantee of lasting appeal. The No. 5 bottle was to give a lesson in modernity that the world would acknowledge. In 1959

it joined the permanent collection at the New York Museum of Modern Art. In 1964 Andy Warhol made it the subject of nine screenprints, catapulting it to new status as an archetype and twentieth-century icon. No. 5 also expressed one of the most intimate facets of Mademoiselle's personality. 'I can't get used to such a contrasting nature as mine,' she would joke. All her creations would be in defense of opposites, cultivating contrasts through combinations of colors and textures. Chanel was never torn between classical reason and baroque imagination. Instead, reconciling extremes became a principle, the brand's image even in these early days. 'Black embraces everything. White too. Their beauty is absolute. They are perfect harmony.' In its white 'cloak' trimmed with black, No. 5 entered into eternity.

With an accomplished strategy of seduction –and marketing before marketing even existed– Gabrielle Chanel launched her fragrance. Wherever her clientele could be found, she made the perfume an object of desire. She celebrated No. 5's 'birth' with Ernest Beaux and some friends in Cannes' finest restaurant. As women walked by she secretly sprayed them with the fragrance from a bottle she held under the table. The effect was instantaneous. Diners stopped in their tracks, sniffed the air, and tried to see where the scent was coming from. Chanel returned to Paris with numerous small bottles of the perfume to give to her best customers. When, seduced by the fragrance, they asked for more she pretended not to have any, claiming it was some trivial gift she'd stumbled upon in Grasse, in a shop whose address she couldn't even remember. Meanwhile, the salons at rue Cambon were fragrant with No. 5. Mademoiselle ensured her entire entourage was addicted to it. When at last she was able to make sufficient quantities, its success was immediate.

If she were to give No. 5 the importance she wanted, Chanel had to find a partner. She met him in 1922. His name: Pierre Wertheimer. He and his brother were the proprietors of Bourjois perfumes, and as such owned one of the most important perfume factories in France. Their partnership, sealed in 1924, would be an unadulterated success for them both. A shrewd businessman with his sights set on international markets, Pierre Wertheimer adopted an original growth strategy for Parfums Chanel based on innovative commercialization, but also groundbreaking communication. His principles, which are still those of the company today, enabled Chanel to become a genuine *parfumeur*, in complete command of each aspect of an activity which must cloak the harsh realities of manufacturing and marketing behind the magic of fragrance. Pierre Wertheimer was soon convinced that No. 5 could conquer America. The United States offered vast potential, with new sectors emerging such as the movies and advertising that would give pride of place to the image. In 1937 Mademoiselle appeared in a magazine, photographed in her suite at the Ritz, to promote her fragrance. In 1939 the outbreak of war forced Mademoiselle to close her couture house, however sales of No. 5 continued. It shot to fame in the United States thanks, among other things, to its easily-remembered name and heavy investment in advertising. On the Liberation of Paris, GIs would queue for hours outside 31, Rue Cambon to take a few bottles of the famous perfume to their wives and girlfriends back home. In 1954, at the height of her fame, Marilyn Monroe told a journalist who inquired about her night-time attire that all she wore to bed were a few drops of Chanel No. 5. Mademoiselle's emblematic perfume went down in history and, spontaneously, found its first ambassadress ... an idea that Chanel would adopt.

Jean Helleu, and above all his son Jacques, were to mastermind a veritable brand image around Chanel's core values of luxury and simplicity. The brand boasts a strong identity that requires the complete

coherency of all the visual elements that surround its fragrances —lettering, colors, bottles and cartons— as well as its print advertisements and commercials. Such an exercise in style demands modesty and rigor, but also creativity and daring. The secret is to model classic codes so that they continue to reflect the prevailing mood. Since the 1920's, the famous bottle has been modified eight times, or rather imperceptibly inflected to counter the aesthetic criteria of each era with the same unwavering purity, the same modernity. Chanel's all-seeing 'eye' with a passion for photography and cinema, Jacques Helleu calls upon the world's most talented image-makers to enrich the brand with their personality and private world. In 1966 he chose Richard Avedon to direct the first No. 5 commercial, an ambitious, sixty-second film. Ridley Scott, Gérard Corbiau and Luc Besson in turn have captured the world's best-selling perfume in offbeat scenarios that have revolution-ized communication in the fragrance segment, from an orchestra rising out of water to a vivacious silk-clad Little Red Riding Hood who isn't at all afraid of the big bad wolf.

Such renowned photographers as Helmut Newton, Irving Penn, Patrick Demarchelier and Daniel Jouanneau have captured the light that exalts the amber color of the fragrance and the stopper's facetted corners, but also the 'faces' who have associated their femininity with No. 5. From Suzy Parker to Estella Warren, from Catherine Deneuve —who between 1968 and 1976 agreed to lend her beauty to Chanel in the United States— to Carole Bouquet whose natural elegance beneath the surface of an apparent ice-coolness epitomized the *française idéale* for the Nineties. Oblivious to the lure of ephemeral fashions, Jacques Helleu has never strayed from the path of simplicity. With each new fragrance he strikes the perfect cord of unostentatious

luxury, staying true to the visual codes that underpin the strength and remarkable unity of Chanel.

recruited as Technical Director for Parfums Chanel in 1924, Ernest Beaux was the company's first ever exclusive fragrance designer. His collaboration with Mademoiselle gave rise to several fragrances inspired by the combination of synthetic scents and natural ingredients that defines Chanel's 'composite-floral' style. Transcending all eras and fashions, some have been reissued and can be discovered in the intimacy and exclusivity of Chanel boutiques. No. 22, which was submitted for Mademoiselle's approval at the same time as No. 5, is in the same revolutionary vein, with its virtuoso formula, apparent simplicity, and mesmerizing floral caress alternating bright and velvety notes to culminate in a full and sensual vibrato. *Gardenia*, lilac, lily of the valley, honeysuckle and the sweetness of apricot create a subtle *trompe l'œil* that gently fades into the delicious powdered accents of vanilla heliotropin. *Bois des Îles* is a wooded cypress fragrance that unfurls into the warmth of sandal and vetiver to conjure up faraway lands and opiate smoke. *Cuir de Russie*, a precursor in androgynous fragrances, interprets a light, leathery scent that hovers between secret emotion and provocation.

Ernest Beaux stepped down in 1954 and was succeeded by Henri Robert. His first creation, in 1955, was *Pour Monsieur*, the only men's fragrances to be launched in Mademoiselle's lifetime. A model of balance and harmony, it leaves a trail of discreet elegance, irresistible charm, and the essence of masculinity. A sublime blend with cashmere undertones, it is the essence of English luxury and aristocratic sophistication that Gabrielle had so admired in the Duke of Westminster. It was not until 1970 that Chanel launched another women's fragrance and the next in

its alchemy of numbers. No. 19 fully captures the spirit of Mademoiselle, who was born on August 19, in its daring and sophisticated fragrance. A burst of neroli for gaiety, and a powdery composition of Tuscan iris, Centifolia rose and narcissus for a bold heart recall the young Coco in her days at Chateau de Royallieu, where she would fuel her insatiable appetite for life in the highly-charged atmosphere of the racetracks. An expert in the art of selecting exceptional ingredients, Henri Robert also created *Cristalle*, in 1974. This composition opens in a flurry of Sicilian lemon and Calabrian mandarin. This bright and luminous overture tells of citrus fruit, picked in the early morning hours from the gardens of Syracuse in honor of Gabrielle on the beach at Deauville or Biarritz: bright, spontaneous, and in love with life. Years later, Jacques Helleu gave this carefree bouquet the face of an up-and-coming model named Claudia Schiffer.

Jacques Polge took up his position as the current creator of Chanel perfumes in 1979 with a threefold objective: firstly, to imagine new fragrances that correspond to the brand's tradition and values; secondly, to adapt and reinterpret the existing fragrances, in particular with the advent of *eaux de parfum* in mind; thirdly, to guarantee the quality of the 'juice,' a decisive factor for the image of Chanel. Jacques Polge was born in France's Provence region and learned his trade as a *parfumeur* in Grasse. His natural reserve hides an extraordinary passion for and knowledge of fragrance. Stored away in his memory are some three thousand olfactory principles, natural ingredients, synthetic molecules, and all the classics of perfumery. Whether in his laboratory at Neuilly, near Paris, Chanel's research unit in Sophia Antipolis, or in liaison with the flower-growers in Grasse who continue to cultivate jasmine and rose exclusively for Chanel, from the selection of the raw materials to blending the concentrate with the alcohol, he decides on, chooses and controls every detail that goes into the creation of a perfume. His technical expertise is matched by his sensibility, the key to the

encounters he provokes between fashion and Chanel's eternal values, nudging him towards intuitions that he transforms into endless reinventions of seduction *à la Chanel*.

*a*ntaeus, created in 1981, rewrote the rulebook for men's fragrance. Jacques Polge looked beyond the compulsive aromatic-fern note that dominated most men's fragrances in the Eighties to imagine another in which leather mingled with wood and spices. This uniquely complex composition requires no less than ninety ingredients. Warm, extrovert, and dressed in deep red by Jacques Helleu, *Antaeus* evokes images of heroes, a fragrance 'Boy Capel', the athletic young man with a solid business background who was also perceptive enough to understand the ambitious young Gabrielle, and help her open her first boutiques. The commercial was directed by Roman Polanski. This epic sequence-length shot calls to mind the mythological references behind Antaeus, son of Gaia and Poseidon.

On the sultry summer's evening of July 23, 1984, an altogether different type of composition filled the air at the Paris Opera. A voluptuous fragrance symphony, whose baroque notes rang out in all their fullness, opened out under the gilded splendor of the Grand Foyer. Journalists from all around the world, in Paris to view the Haute Couture collections, gathered for the launch of *Coco*. Opulent and sensual, a tribute in black and gold, it plunges us into the turbulence of Venetian festivities, on stage with the Ballets Russes, or at the court of the Tsars. Mademoiselle's apartment on rue Cambon with their richly lacquered Coromandel screens inspired Jacques Polge to dream up this spicy-floral-amber fragrance, born of the imaginary union between East and West. The succulence of orange blossom and mandarin leads into a luxuriant heart of rose and oriental jasmine, ylang-ylang and mimosa.

The mysterious and torrid aroma of Tonka bean and patchouli linger. Personified first by Inès de la Fressange then Vanessa Paradis, *Coco* captures the impertinence of Gabrielle, carefree and unconventional even in her manner of seduction.

Chanel has always found harmony in contrast. And so in 2001 Jacques Polge imagined *Coco Mademoiselle*, the other face of Coco. It marked a return to sobriety, with a fresh fragrance and light, almost abstract, notes of morning rose and jasmine petals. Kate Moss lent her lithesome silhouette to this luminous, pure and totally contemporary fragrance.

e*goïste* marked the beginning of Chanel's collaboration with Jean-Paul Goude, in 1990. A creator in a class of his own who cut his teeth in advertising, his style is permeated as much by comic-strips as by cinema epics. His was the imagination behind the 1989 celebrations of the Bicentennial of the French Revolution in Paris. Jacques Helleu sensed the affinities between Chanel and Goude: the same highly personal 'inner world' and independent spirit, backed by the same implacable rigor and professionalism.

Once again, Jacques Polge's original and affirmative fragrance went against the grain of men's fragrances, in particular thanks to the intense and unusual persistence of sandalwood and bourbon vanilla. The fragrance is as impertinent as its name, which Jean-Paul Goude portrayed in a bold and creative commercial. His work was awarded a Lion d'Or at the 37th International Advertising Film Festival in Cannes. With Jacques Helleu's full approval, Goude didn't hesitate to reconstruct a replica of a famous Côte d'Azur hotel in Brazil. At each window, a beautiful model in a Chanel gown hurled tragic imprecations at the 'Egoïst,' the only glimpse of whom was his hand, setting down a bottle of the fragrance on the balcony of his closed room in a gesture of irredeemable indifference.

Later, this time for *Coco*, Jean-Paul Goude reinvented desire in a story of a cat and a bird. As a bird of paradise, Vanessa is both innocent and provocative as she swings on her perch inside a fifteen-metre high gilded cage, spilling perfume from a giant bottle.

In 1993, *Platinum* breathed brightness and energy into *Égoïste* to give it a fresh-herbaceous-woody spirit. Goude gave it a face, that of a seductive boxer sparring with his shadow while trying to seize the precious bottle from which he derives his strength. The commercial ends with a shot of his bandaged hand setting down the bottle on the balcony of his room in a luxury hotel, a tongue-in-cheek reference to Goude's first commercial.

I n 1996 *Allure* was born. Irresistible. Indefinable. Paul Morand came close to capturing Chanel's allure, although it can never quite be caught. Its chic and sober bottle wears a jewelry-like gold ring and almost flesh-toned Chanel beige. All it takes for the six facets of this kaleidoscope fragrance by Jacques Polge to reveal themselves is to vibrate against a woman's skin. Each time it echoes and magnifies her personality. Three years later *Allure* adopted a fresh-spicy-woody tone to talk to men about authentic values and invite them to be themselves. By doing so they affirm all that is unique and irreplaceable in their seductive appeal. Behind these facets are faces: the determined Gabrielle, the impertinent Coco, and the elegant Mademoiselle. And those of the men she loved: Grand-Duke Dimitri Romanov, the Duke of Westminster, and Paul Iribe. We also discover the caliber of a Diaghilev, the spirit of a Cocteau, and the visionary inspiration of a Stravinsky. For friends or lovers, princes or poets, *Allure* whose advertising campaign is their updated reflection, multiplied to infinity. Herb Ritts and Patrick

Demarchelier shot black and white portraits, free from all artifice, of men and women who were chosen for their inner beauty and the sincerity that can be read in their eyes. Each one expresses, in complete serenity, the art of being oneself. For some, allure is a form of grace. For Chanel, it is a floral-composite manifesto in defense of difference. The essence of Chanel fragrances.

For Chanel, 2003 is the year of chance – *Chance*, the new women's fragrance by Jacques Polge. Infused with optimism, it is pink and tender inside its surprisingly round bottle, the work of Jacques Helleu. It is a fragrance full of contrast, shadow and light, very like Chance that one must seize before it is too late. Waves of freshness combine with floral notes, then fuse with the sensual, spicy, rich accents of hyacinth, white musk, pink pepper, jasmine, citron and vetiver in an ardent, joyful, and infinitely moving constellation. In the commercial, chance appears out of nowhere, when eyes meet suddenly it is love. Its setting is the legendary decor of Venice, a cult city that gave Mademoiselle the opportunity for some key encounters, including with film-director Lucchino Visconti. When Jean-Paul Goude meets *Chance*, everything becomes possible, even recreating a Venetian quayside in a film studio so as to enjoy the best possible depth of focus, and also carefully orchestrate each movement, each silhouette of the cast to ensure their role is a true reflection of the brand's universe. Chance, according to Chanel, smiles on those who are bold enough to brave convention. Chance is something we attract and which in a single second can transform a life into a destiny. A life made of fragrance. Because the love affair between Chanel and chance will go on for ever.

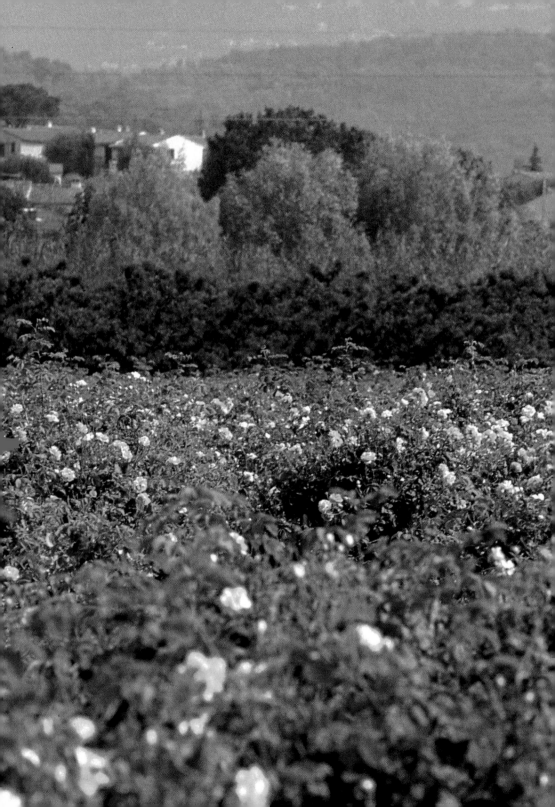

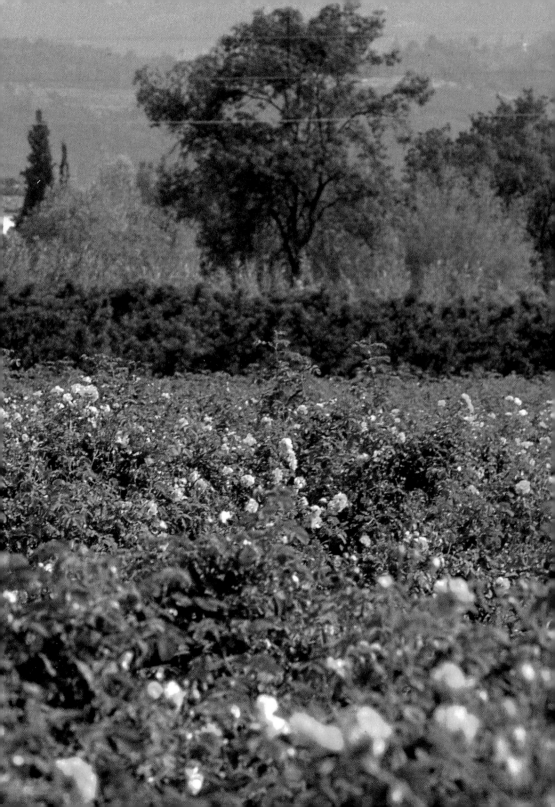

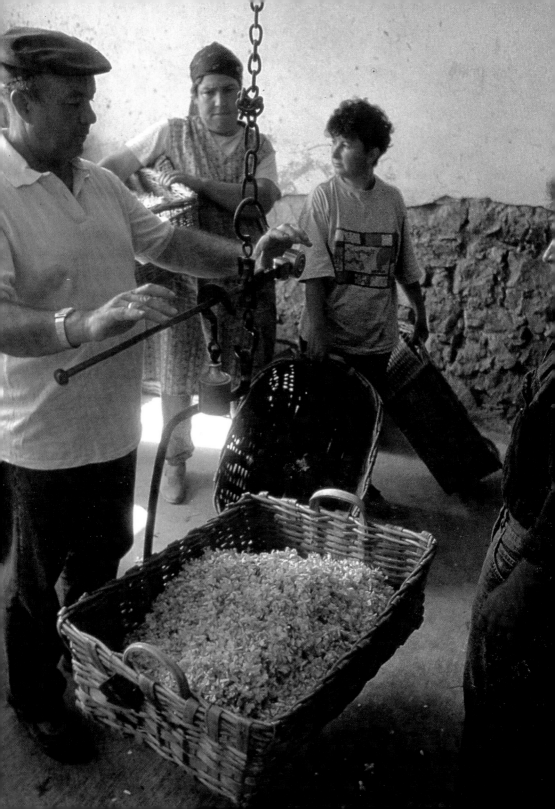

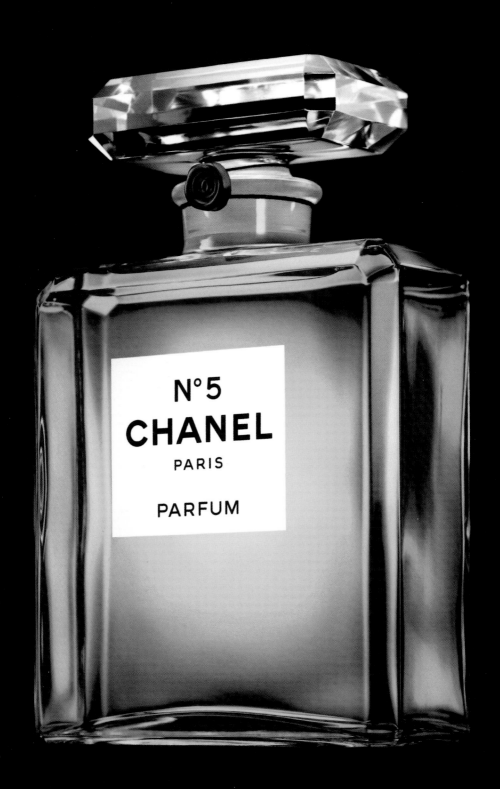

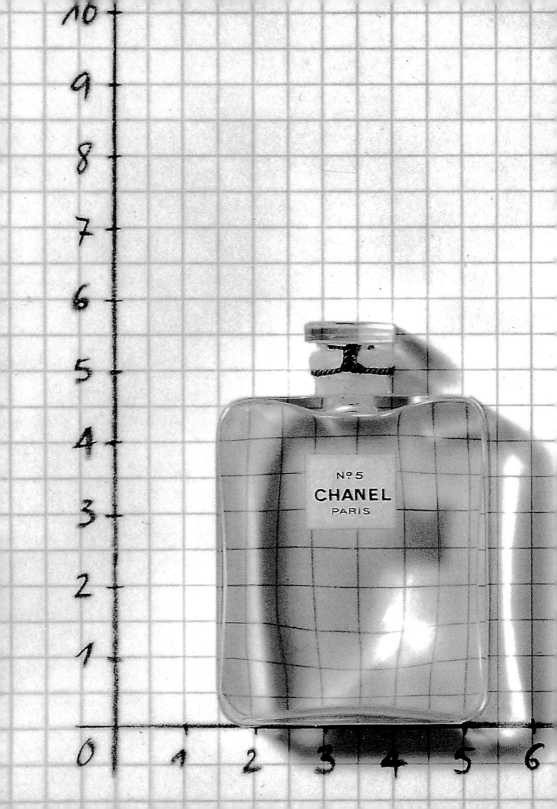

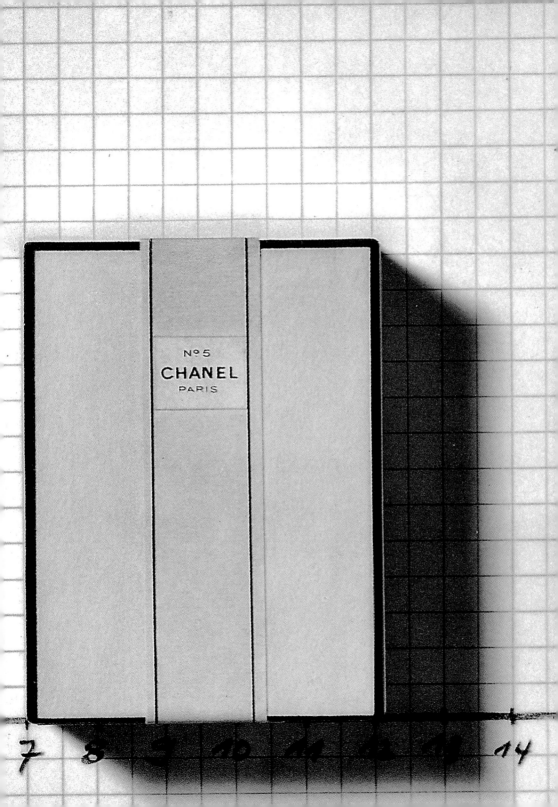

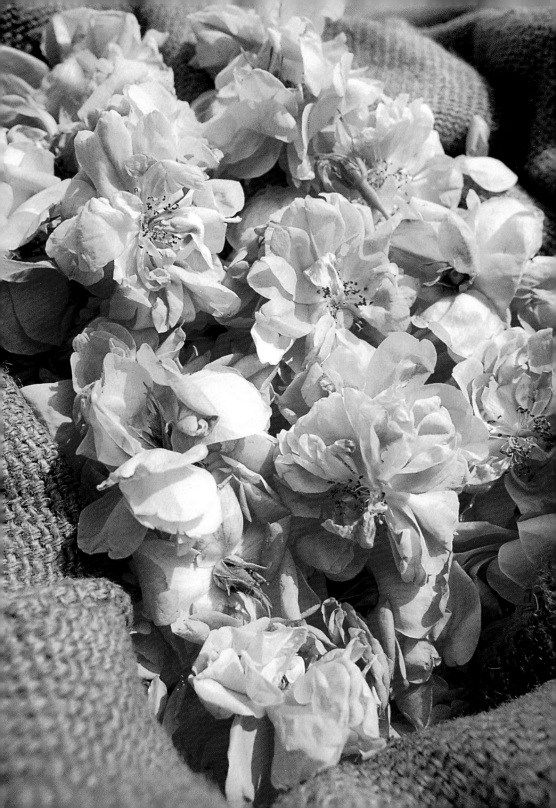

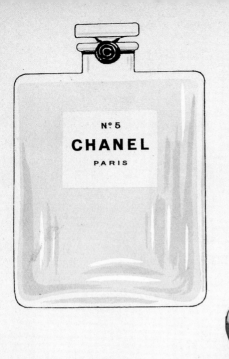

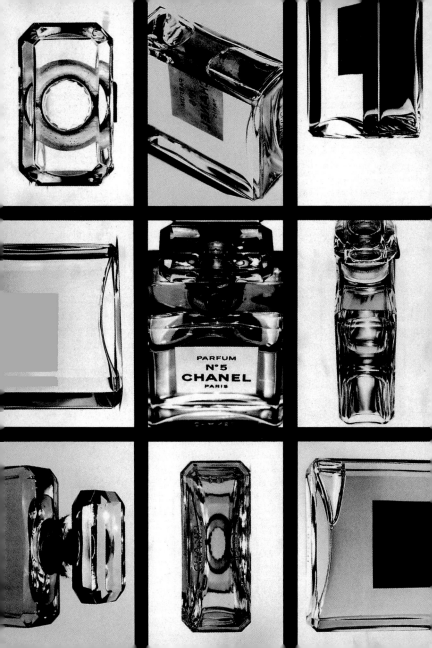

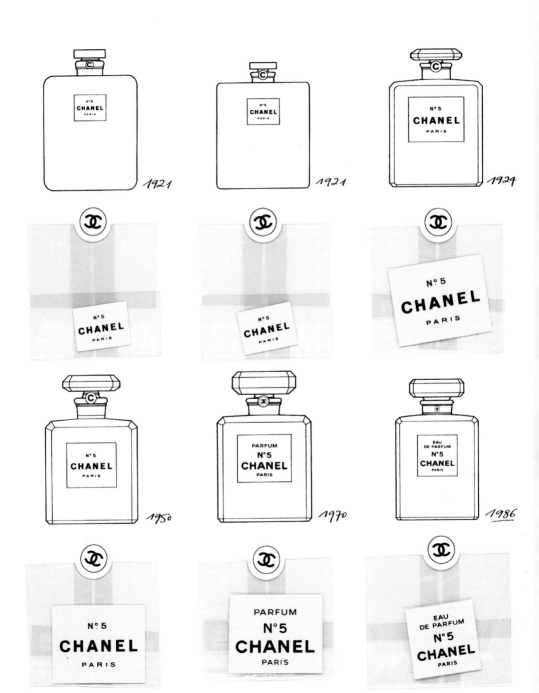

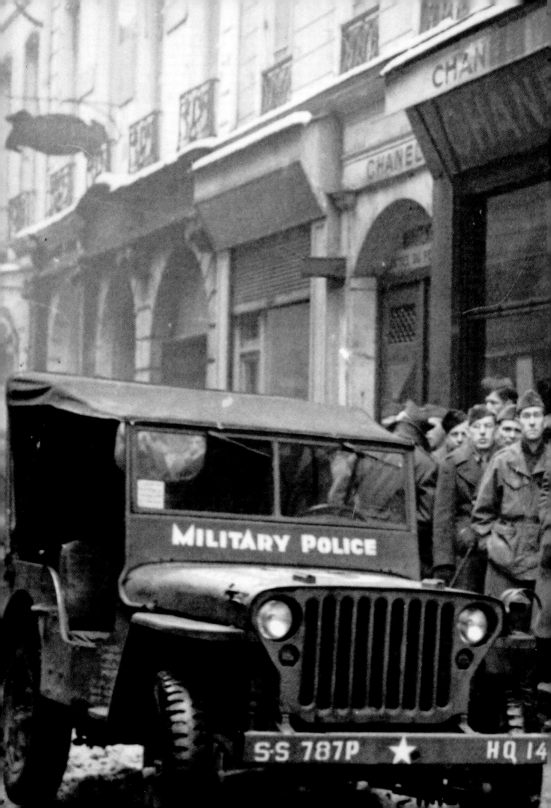

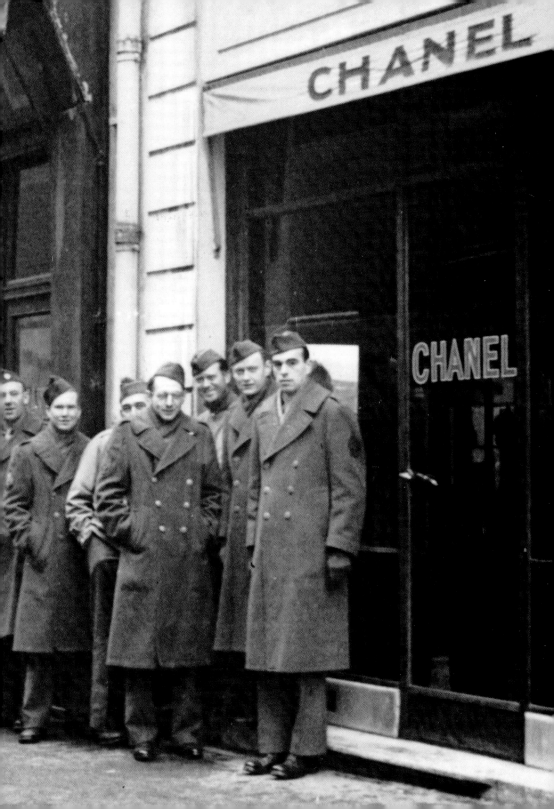

"I lose my sense of smell without it."

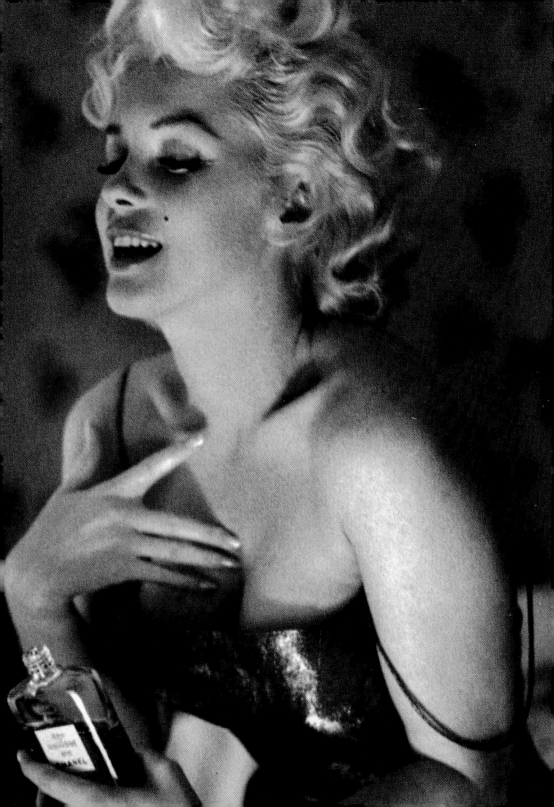

ABSOLUE JASMIN

GRASSE

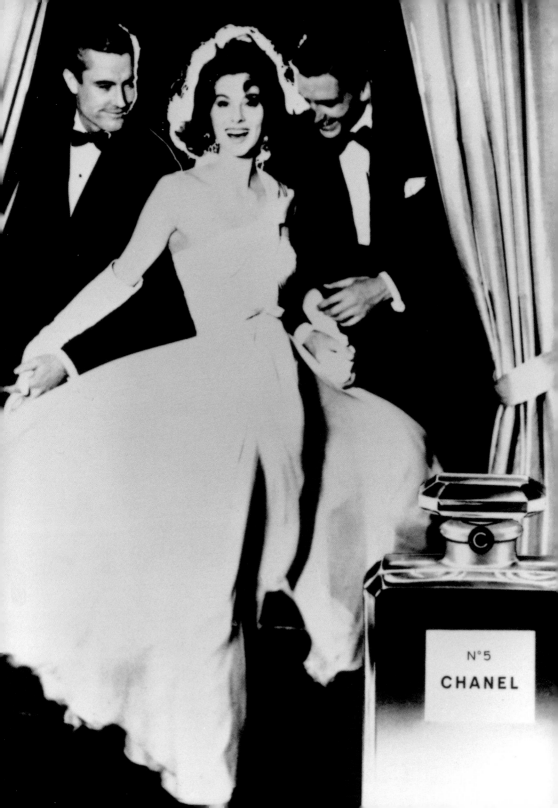

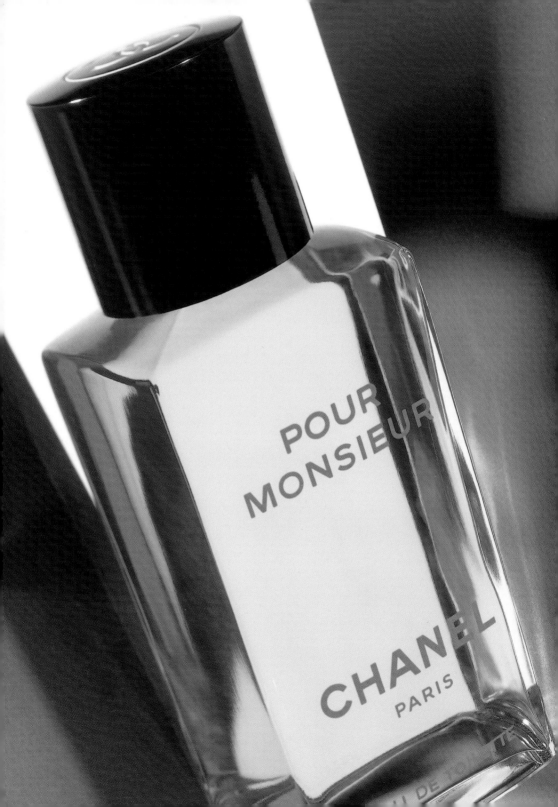

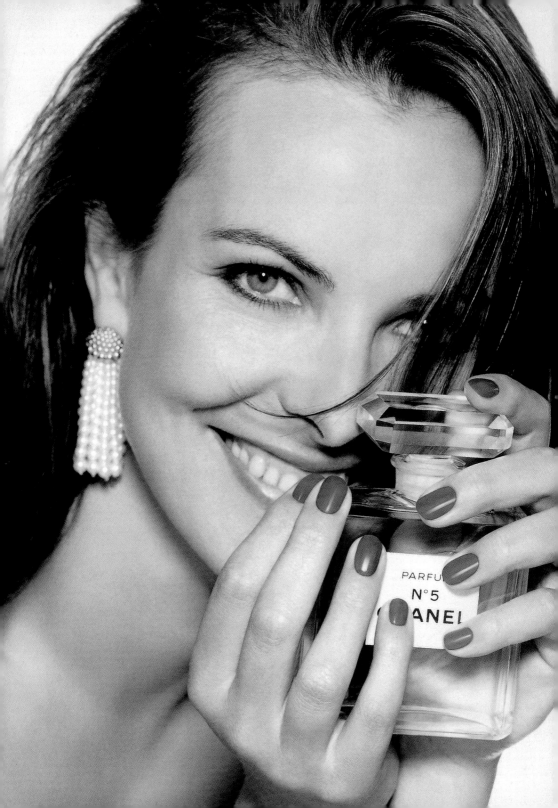

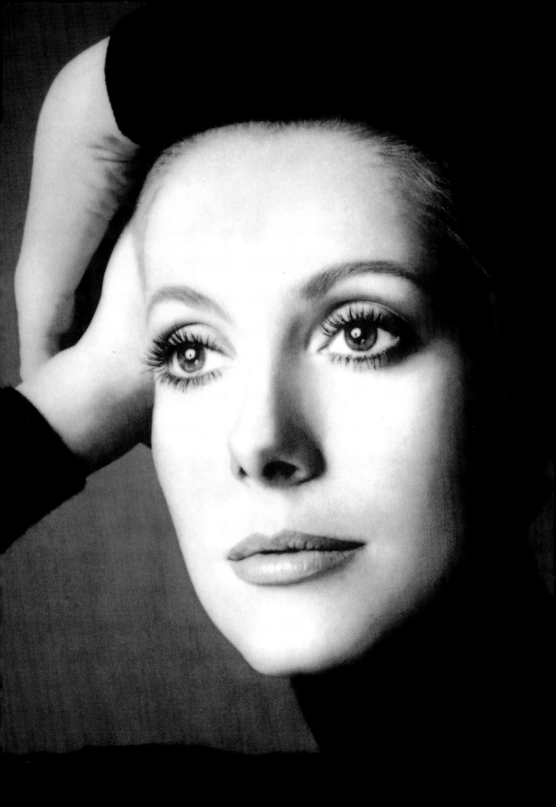

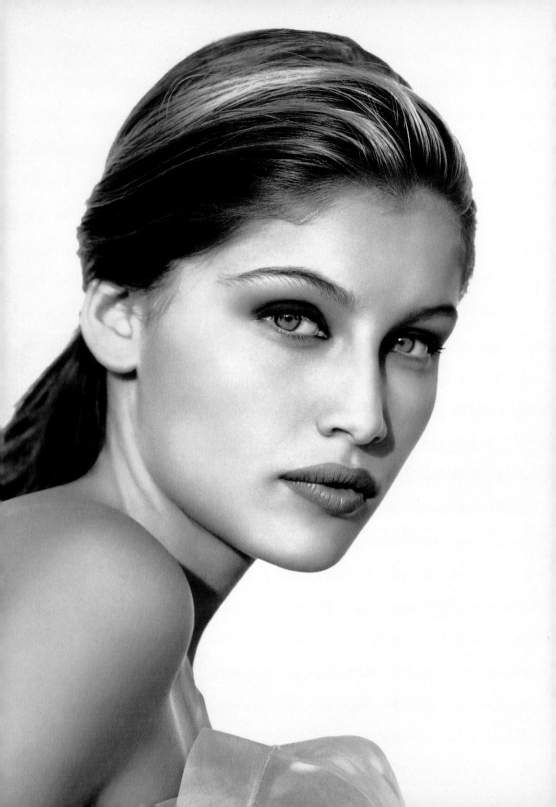

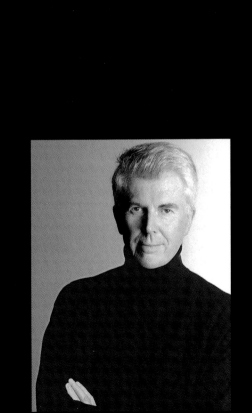

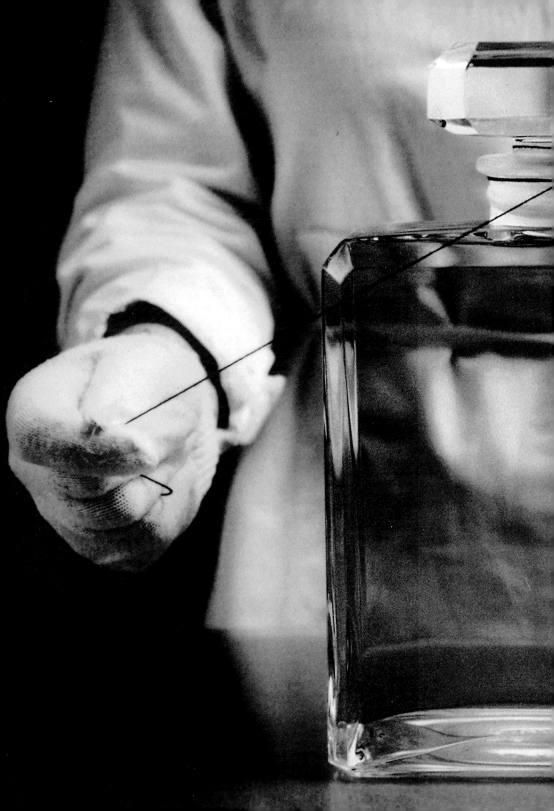

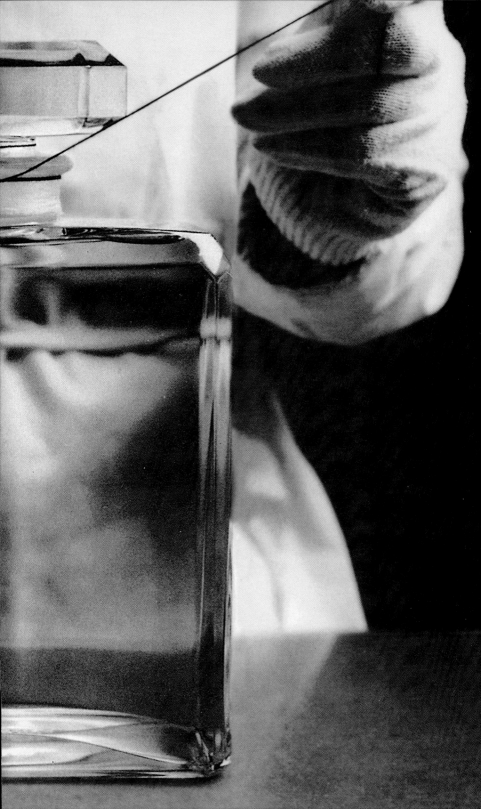

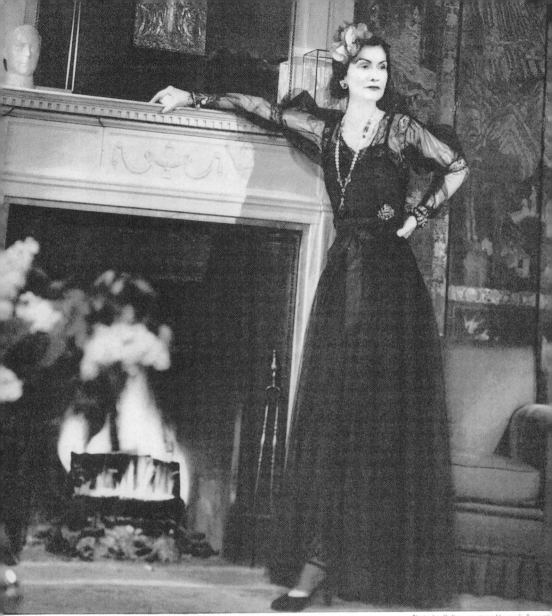

Madame Gabrielle Chanel in her new apartment in the Ritz, Paris

Madame Gabrielle Chanel is above all an artist in living. Her dresses, her perfumes, are created with a faultless instinct for drama. Her Perfume No. 5 is like the soft music that underlies the playing of a love scene. It kindles the imagination; indelibly fixes the scene in the memories of the players.

No. 5
CHANEL

LES PARFUMS
CHANEL

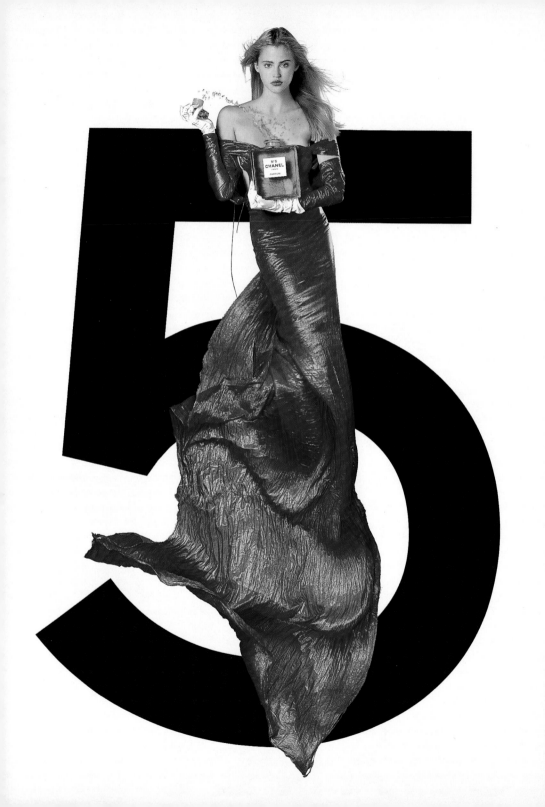

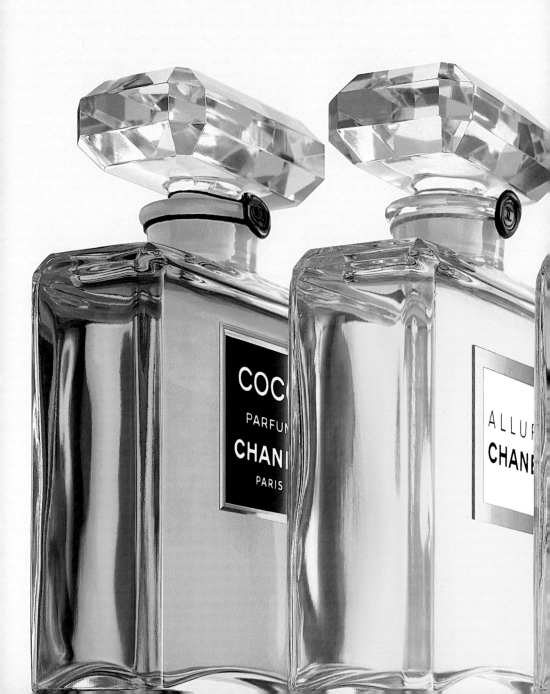

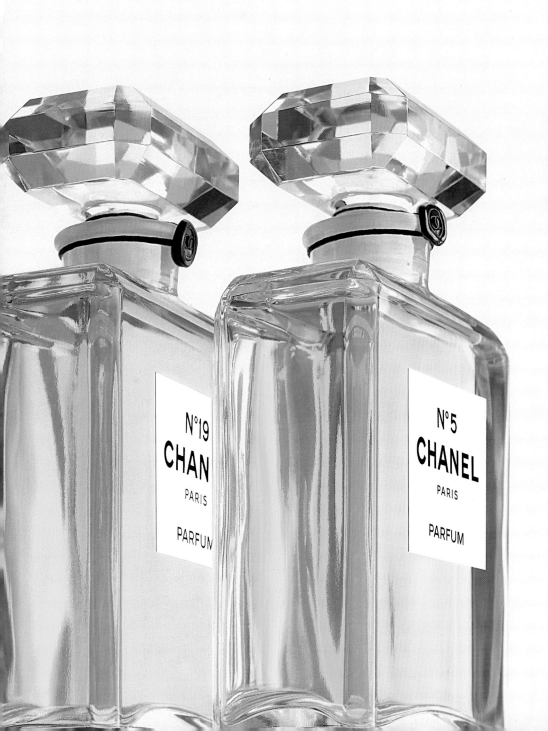

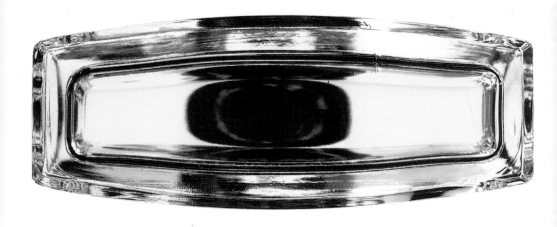
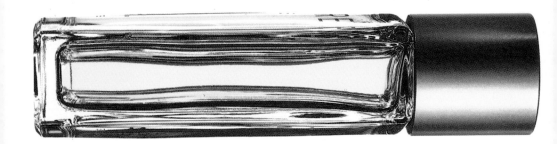

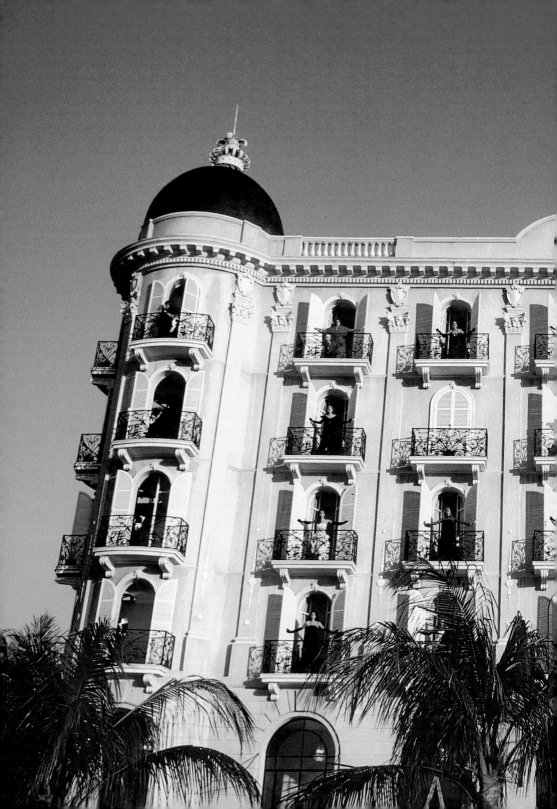

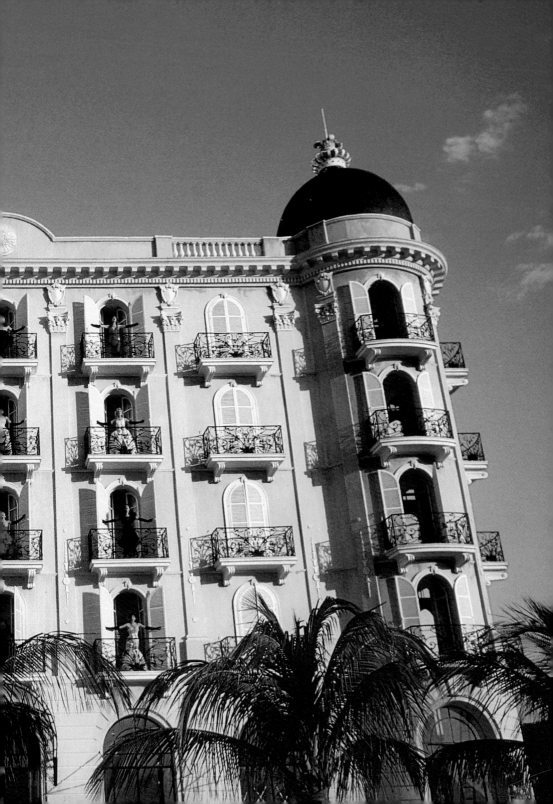

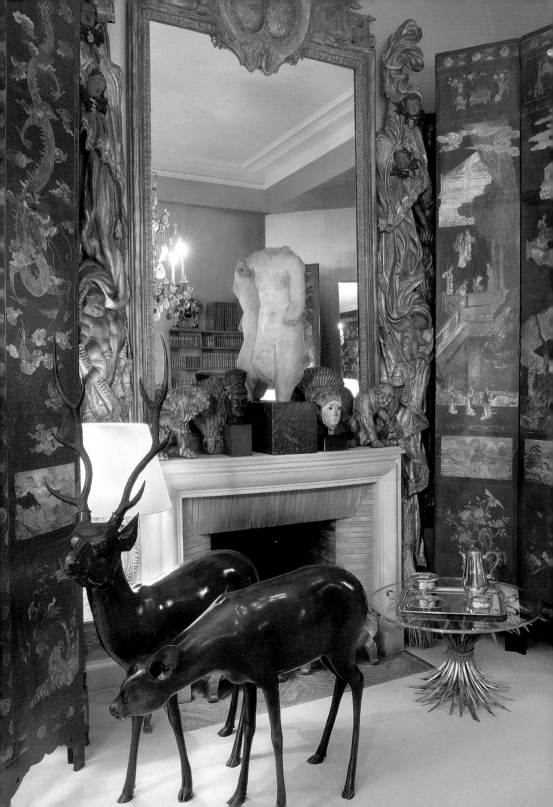

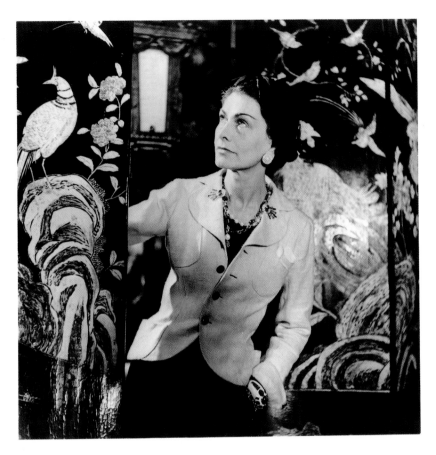

"I want to part of what is going to happen."

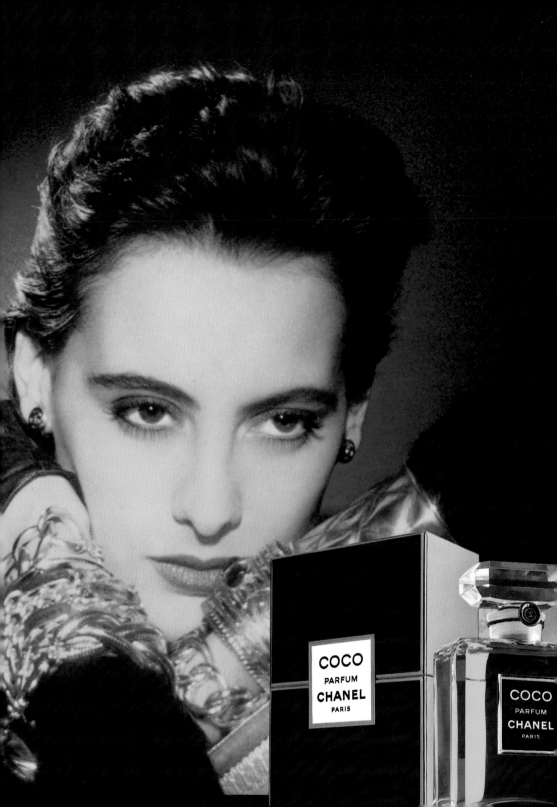

COCO

PARFUM

CHANEL

PARIS

COCO

PARFUM

CHANEL

PARIS

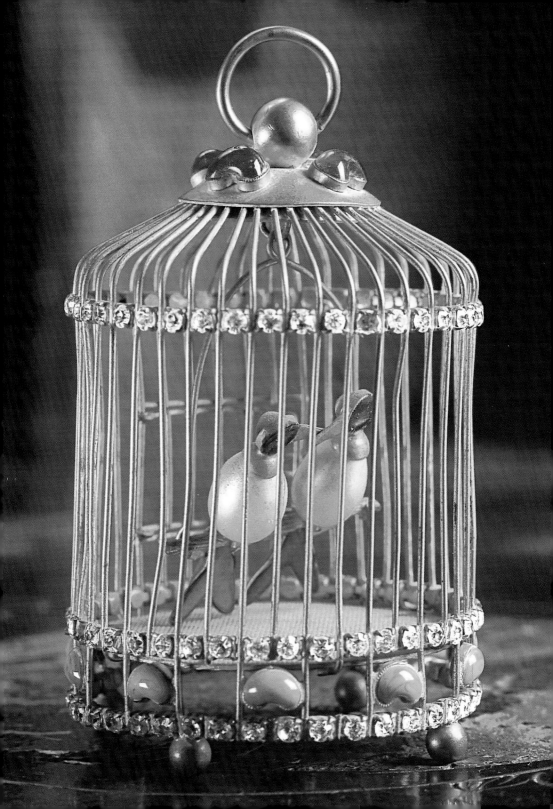

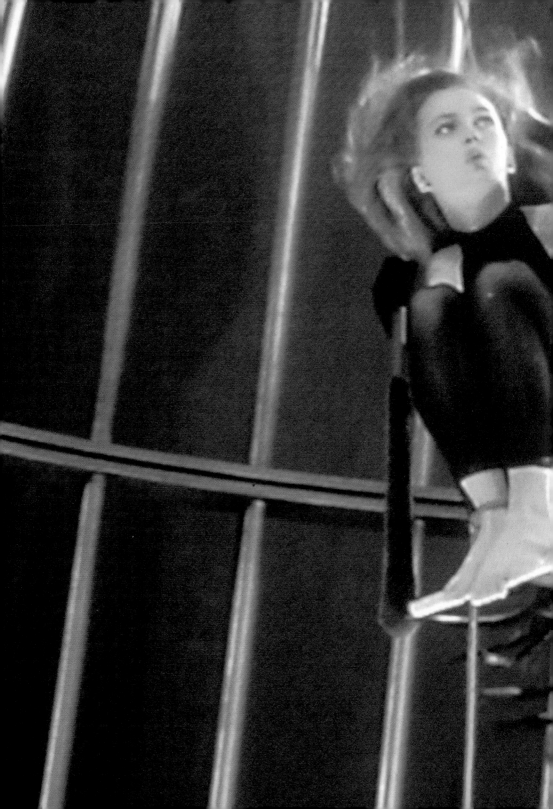

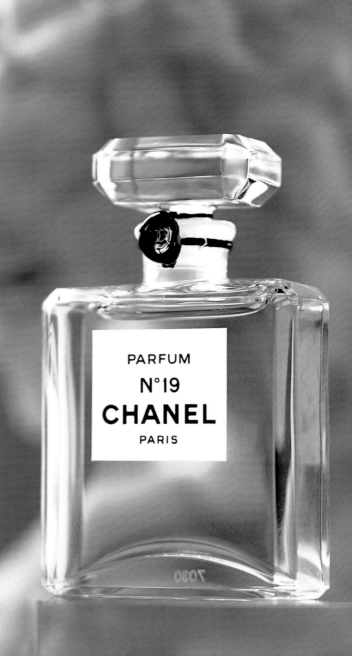

PARFUM

N°19

CHANEL

PARIS

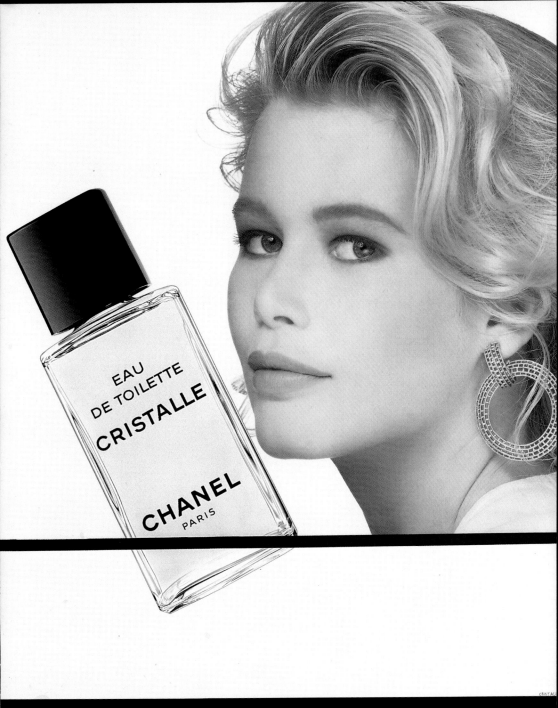

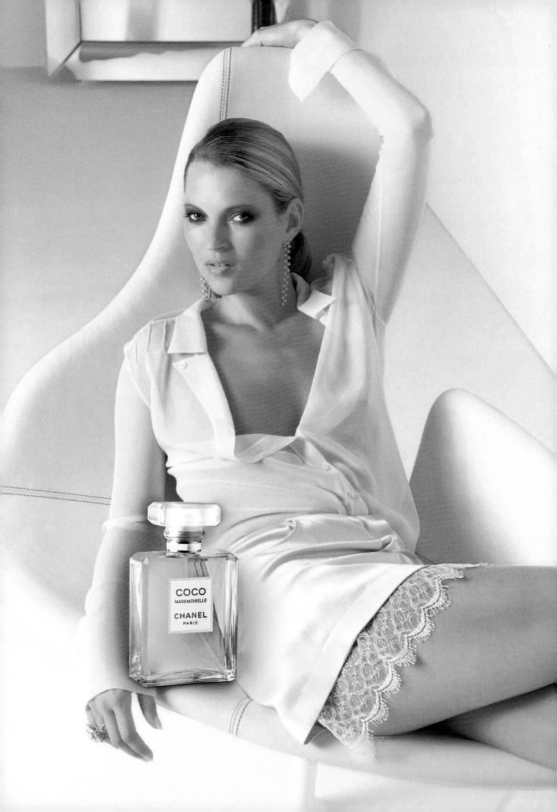

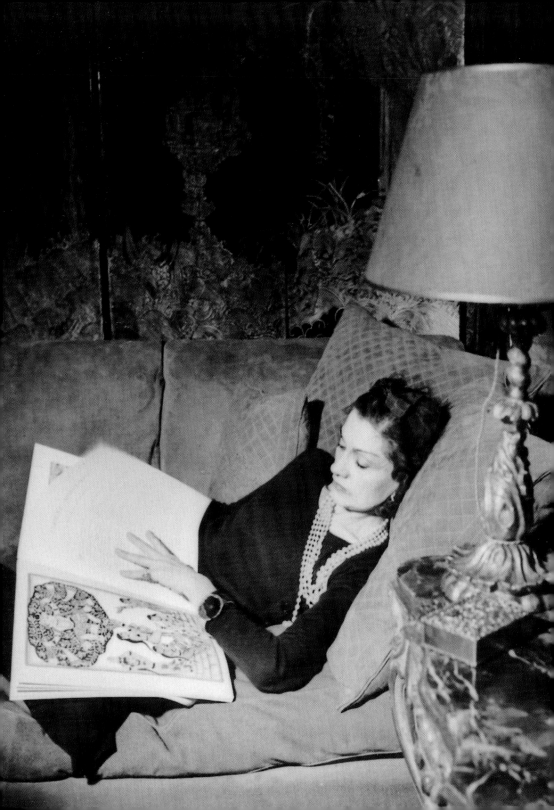

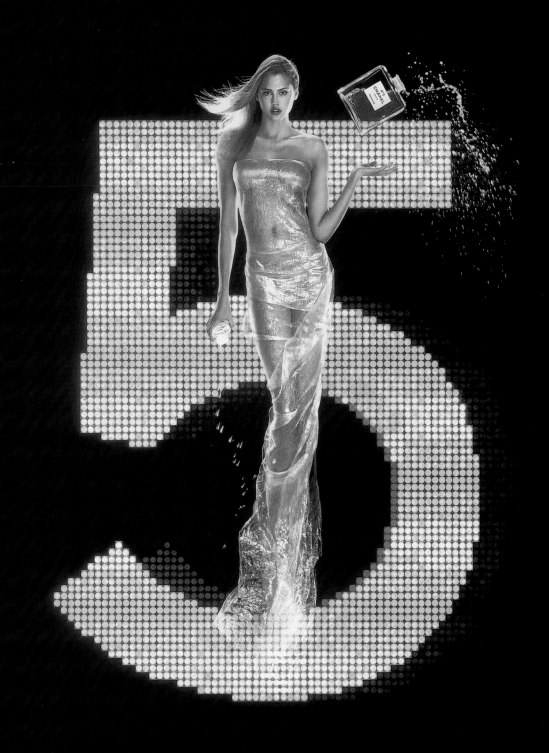

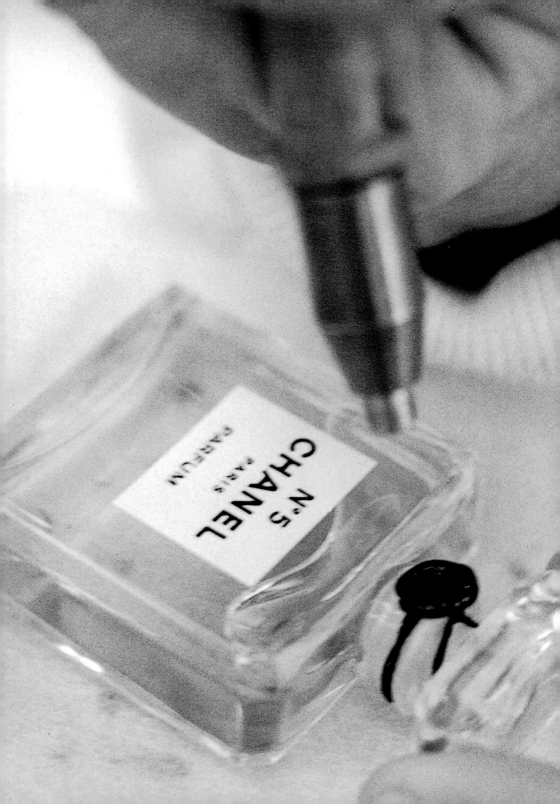

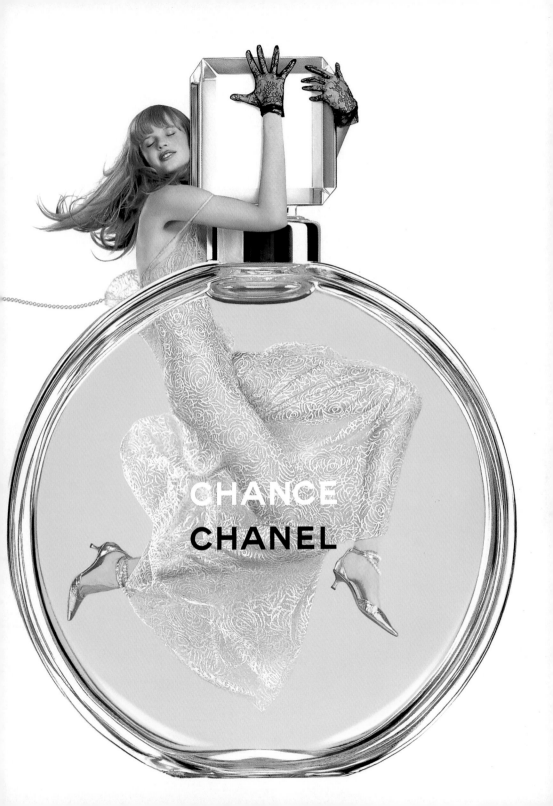

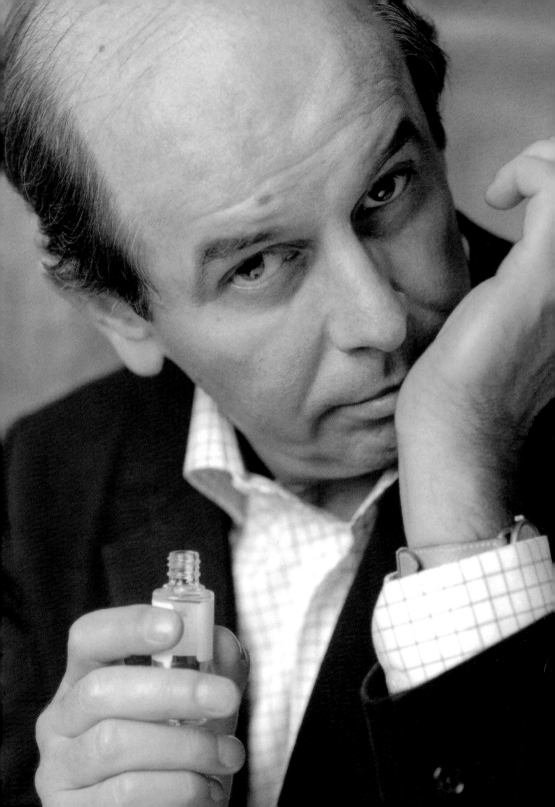

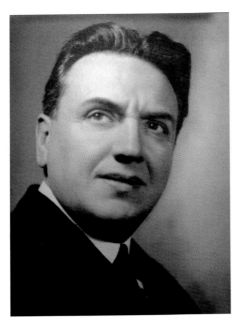 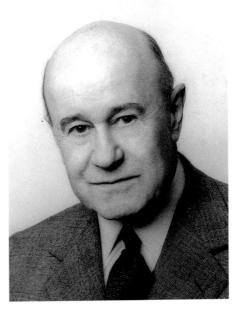

Ernest Beaux Henri Robert

Jacques Polge

Chronology

1883: Gabrielle Chanel is born in Saumur, France on 19 August.

1910: Chanel, from now on known as 'Coco', sets up a hat shop at 21, rue Cambon, Paris, under the label 'Chanel Modes'.

1921: Launch of the first Chanel perfume: No. 5. This 'woman's fragrance with a woman's scent' was revolutionary in its composition, name and presentation. It owes its existence to the encounter between Gabrielle Chanel and the perfumer Ernest Beaux, who would remain the brand's exclusive perfume designer ("nose") until 1952. Opening of the showrooms at 31 rue Cambon.

1922: Launch of the No. 22 fragrance.

1924: Creation of Société des Parfums Chanel which distributes Chanel perfumes and beauty care. Mademoiselle Chanel's beauty credo –'Be yourself and wear what suits you'– is reflected in the company's facial care products, cosmetics and perfumes.

1925: Launch of the *Gardenia* fragrance.

1926: Launch of the *Bois Des Iles* fragrance.

1927: Launch of the *Cuir De Russie* fragrance. Inspired by masculine perfumes, and a precursor in androgynous fragrances, it illustrates the avant-garde spirit that reigned at Chanel Perfumes.

1932: Chanel unveils her first fine jewelry collection on the theme of diamonds and platinum in her private salons at 29, rue du Faubourg-Saint-Honoré in Paris.

1939: The couture house closes. Only the boutique at 31, rue Cambon remains open, where perfumes and accessories continue to seduce the company's clientele.

1945: The fame of No. 5 is such that GIs queue outside 31, rue Cambon to take home this exceptional gift.

1952: Henri Robert takes over form Ernest Beaux as the 'nose' at Chanel Perfumes.

1953: At 71 years of age, Chanel returns to haute couture. The first model in the collection is the 'No. 5' jersey suit.

1955: Launch of Chanel's first men's Eau de Toilette: *Pour Monsieur.* When asked by a reporter what she wears in bed, Marilyn Monroe replies 'Chanel No. 5' and in doing so helps sustain the perfume's legendary reputation.

1956: Chanel is the first perfume brand to use television for its communication, with a commercial for No. 5 in the United States.

1959: The form of the No. 5 bottle earns it a place in the permanent collection of New York's MOMA.

1964: Andy Warhol, who consider No. 5 to be a twentieth-century icon, immortalizes the bottle in a series of screenprints.

1965: Jacques Helleu is appointed advertising director at Chanel, prior to becoming artistic director for Chanel perfumes and beauty products a few years later.

1966: Jacques Helleu asks Richard Avedon to produce a commercial for No. 5.

1968: The French actress Catherine Deneuve becomes the face of No. 5 for the American advertising campaign, photographed by Richard Avedon and Helmut Newton. Over fifty commercials are filmed in all.

1970: Launch of Chanel No. 19. Created by Henri Robert at Mademoiselle Chanel's request, its name is inspired by her birth date (19 August, 1883).

1971: Mademoiselle Chanel passes away on 10 January in Paris, on the eve of the presentation of her collection.

1974: Launch of *Cristalle* Eau de Toilette.

1975: Launch of the *Noir et Or* beauty care and cosmetics line.

1979: Jacques Polge becomes Chanel's third perfume designer. The last 'nose' to work exclusively for one brand, he is to mastermind all Chanel's fragrance creations.

1981: Launch of *Antaeus* Eau de Toilette for men.

1983: Karl Lagerfeld is appointed Artistic Director for Haute Couture, Ready-to-Wear and Accessories.

1984: Launch of *Coco*, which takes its name from Gabrielle Chanel's nickname.
The model Inès de la Fressange plays Coco in a series of commercials, directed by Jacques Helleu.

1986: The French actress Carole Bouquet becomes the face of No. 5.

1987: Creation of Chanel Watches.

1990: Launch of *Égoïste* Eau de Toilette.
The commercial by Jean-Paul Goude is awarded a Lion d'Or at the 37th International Advertising Film Festival at Cannes.

1993: Launch of *Égoïste Platinum* Eau de Toilette.
Launch of Chanel Jewelry.

1996: Launch of *Allure*, whose advertising campaign is built around a portfolio of black and white portraits.

1997: No. 5 captures the public's attention with an international advertising campaign that uses the Andy Warhol screenprints.

1998: Under the artistic direction of Jacques Helleu, Luc Besson gives his interpretation of No. 5 with an unexpected Little Red Riding Hood.

1999: Launch of *Allure Homme*.
Creation of *Précision*, the new Chanel beauty care line.

2001: Launch of *Coco Mademoiselle* Eau de Parfum.

2003: Launch of *Chance*, a radiant and optimistic composition in a surprising round bottle and pink packaging.
The commercial by Jean-Paul Goude portrays a love-struck couple in Venice.

Chanel Perfume

May comes to the rose fields in Grasse. It takes more than a tonne of petals to produce 1.5 kilos of the absolute from which the perfume is made, and an hour to hand-pick 6 or 7 kilos of flowers. © Chanel/Photo Cyril Le Tourneur d'Ison.

Weighing jasmine in Grasse. In order to preserve No. 5's identity, Chanel continues to grow Grandiflorum jasmine in the south of France. Its unique fragrance properties set the standard for quality and tradition in perfume throughout the world. © Chanel/Photo Cyril Le Tourneur d'Ison.
The famous Chanel No. 5 bottle. © Chanel/Photo Nick Welsh.

The No. 5 bottle and carton, created in 1921 by Mademoiselle Chanel. Its pure silhouette, ideal proportions and distinctive black and gold raised it to the rank of twentieth-century icon. © Chanel/Photo Guy Gallice.

The Centifolia or Cabbage rose. This round, highly perfumed flower blooms once a year for just three weeks. It brings a superbly feminine harmony to the heart of No. 5. © Chanel/Photo Louis Bourjac.
Mademoiselle Chanel and No. 5, caricatured by Sem in 1921. © ADAGP, Paris 2003.

The multiple facets of the No. 5 bottle. Graphic from all angles, through the crystal the light signs contrasts of black and white. Imperceptibly, the bottle evolves to nurture the same unique spirit, independently of moments and moods. © Chanel/Photo Axel Tilche.

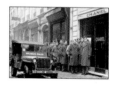

GIs queue outside the Chanel boutique in rue Cambon in 1945. On the Liberation of Paris, American soldiers were eager to take bottles of No. 5 back home to the States, where the fragrance had become hugely famous. © Chanel/Photo Serge Lidot.

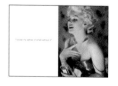

Marilyn Monroe, a legendary ambassadress for No. 5. In 1954 she declared that all she wore to bed were a few drops of Chanel No. 5. With these words she became the first personality to be associated with the fragrance. Her powers of seduction echoed the extraordinary femininity of the perfume. © Michael Ochs Archives/Jour de France, May 1960/Photo Feingersh.

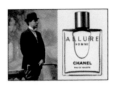

Ernest Beaux, creator of Chanel No. 5. By combining aldehydes with natural ingredients he invented the composite-floral style that characterizes the spirit of Chanel perfumes. © Chanel.
Allure Homme, created in 1999 by Jacques Polge, in the bottle designed by Jacques Helleu. © Chanel/Photo Didier Roy.

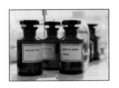

The Chanel perfume laboratories in Grasse. Volatile solvents are used to extract the active principles of rose and jasmine, which are made first into concrete then into absolute. Chanel uses this and no other process for No. 5, as it best captures the intensity of the flower. © Chanel/Photo Louis Bourjac.

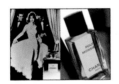

Suzy Parker, photographed in 1957 by Richard Avedon. She was one of the first 'faces' that Chanel chose to personify No. 5. © Photo Richard Avedon.
Pour Monsieur **was Chanel's first fragrance for men.** It was created in 1955 by Henri Robert, who succeeded Ernest Beaux as Chanel's exclusive perfume designer. © Chanel/Photo Didier Roy.

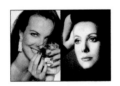

The faces of Chanel. Carole Bouquet, photographed in 1997 by Patrick Demarchelier. Her natural elegance and beauty seduced Jacques Helleu, who chose her to represent No. 5 in the nineteen-nineties. © Chanel/Photo Patrick Demarchelier. © Catherine Deneuve, photographed by Richard Avedon for a Chanel No. 5 campaign that was shown exclusively in the United States between 1968 and 1977.

Laetitia Casta, photographed by Herb Ritts in 1996. Hers was one of the faces chosen by Jacques Helleu for the first Allure campaign. © Chanel/Photo Herb Ritts.
Jacques Helleu, artistic director at Chanel. He has defined the brand's visual codes and developed an exceptionally coherent image. He is also the 'eye' behind its advertising. © Chanel/Photo Didier Roy.

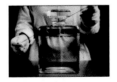

The bottle is sealed with a translucent membrane, trimmed with four rows of black corded cotton as the ultimate finishing touch. This time-honored technique is now reserved exclusively for No. 5 *extrait de parfum*. © Chanel/Photo Laziz Hamani.

No. 5 as seen by Andy Warhol. Chanel used some of the artist's 1964 screen-prints for an advertising campaign in 1997. © Andy Warhol Foundation/ADAGP, Paris 2003.
Mademoiselle Chanel herself, here in her suite at the Ritz in 1937, was the face of No. 5 for an advertising campaign in Harper's Bazaar. © ARDP/Photo François Kollar.

Estella Warren, photographed by Jean Paul Goude for No. 5 in 1999. © Chanel/Photo Jean-Paul Goude.
According to Mademoiselle Chanel, an extrait de parfum should be worn 'where one wished to be kissed.' A single drop suffices wherever a heartbeat can be heard. © Chanel/Photo Didier Roy.

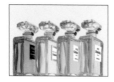

Chanel perfumes. All share the same strict geometry, the same graphic style, and the same simplicity. Never ostentatious, they embody luxury in its most classic form. © Chanel/Photo Didier Roy.

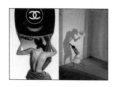

The *Antaeus* advertising campaign by Helmut Newton in 1993. © Chanel/Photo Helmut Newton.
The print advertisement and commercial for *Égoïste Platinum* by Jean-Paul Goude in 1993. © Chanel/Photo Jean-Paul Goude.

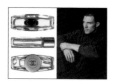

Allure Homme, created by Jacques Polge in 1999 and the first men's perfume to become one of the world's Top Ten fragrances. On the right, the Brasilian architect André Balazs, one of the faces of the advertising campaign, chosen by Jacques Helleu. © Chanel/Photo Patrick Demarchelier.

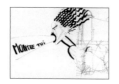

The storyboard for the *Égoïste* commercial, drawn by Jean-Paul Goude in 1990. These panels of sketches depict the important changes of scene and are essential when preparing to shoot. © Chanel/Photo Jean-Paul Goude.

A famous hotel on the Côte d'Azur was recreated in Brazil for the *Égoïste* commercial, directed by Jean-Paul Goude in 1990. © Chanel/Photo Jean-Paul Goude.

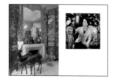

Mademoiselle's apartments on rue Cambon. Their baroque decoration inspired Jacques Polge to create *Coco*. © Chanel/Photo Olivier Saillant.
Mademoiselle surrounded by her Coromandel screens in her apartments on rue Cambon. © Photo Lipnitzki-Viollet, 1937.

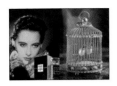

Inès de La Fressange, who was first to play Coco, photographed by Paolo Roversi in 1993. © Paolo Roversi.

The birdcage in Mademoiselle's apartments on rue Cambon. It inspired Jean-Paul Goude for his 1991 commercial with Vanessa Paradis. © Chanel/Photo Olivier Mauffrey.

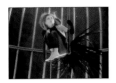

Vanessa Paradis, filmed by Jean-Paul Goude in a fifteen-meter high gold cage, embodied the free spirit of Coco in the early nineteen-nineties. © Chanel/Photo Jean-Paul Goude.

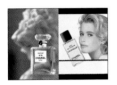

No. 19, created in 1970 by Henri Robert. Its name refers to the birth date of Mademoiselle Chanel, a Leo who came into the world on August 19. © Photo Olivier Mauffrey.

Claudia Schiffer, who was chosen by Jacques Helleu to embody the freshness of Cristalle in 1992. © Chanel/Photo François Lamy.

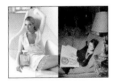

Kate Moss, photographed by Mickael Thompson, lends her allure to *Coco Mademoiselle* in 2003. © Chanel/Photo Mickael Thompson.

Mademoiselle Chanel on her sofa at rue Cambon in 1937. © A.P.H. Christian Bouqueret, Paris/Photo Jean Moral.

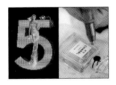

Estella Warren, photographed by Jean-Paul Goude for the No. 5 advertising campaign in 2002. © Chanel/Photo Jean-Paul Goude.

The final stage when manufacturing a perfume, the wax seal guarantees the integrity of the fragrance. © Chanel/Photo Louis Bourjac.

Chance, a supremely optimistic fragrance created by Jacques Polge in 2003. It is represented by Anna Vyalitsyna, who in a passionate gesture seizes its unusual round bottle, the work of Jacques Helleu. © Chanel/Photo Jean-Paul Goude.

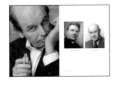

The three master perfumers who in turn have lent their genius exclusively to Chanel. Left, Jacques Polge, the current perfume designer. © Chanel. Right, Ernest Beaux and Henri Robert. Each, through their talent, has succeeded in capturing the inimitable spirit of Chanel in fragrance. © Private Collection.

The publisher wishes to thank Marie-Louise de Clermont-Tonnerre, Marika Genty, Mireille Bonville, Jacques Helleu, Francis Vandenbussche as well as Patrick Doucet for the help they have given in the production of this book.

Thanks are also due to André Balazs, Carole Bouquet, Laetitia Casta, Catherine Deneuve, Inès de La Fressange, Kate Moss, Vanessa Paradis, Suzy Parker, Claudia Schiffer, Anna Vyalitsyna, Estella Warren, as well as to Richard Avedon, Gilberte Beaux, Anne-Catherine Biedermann (AFDPP), Christian Bouqueret (A.P.H.), Louis Bourjac, Patrick Demarchelier, Guy Gallice, Véronique Garrigues (ADAGP), Jean-Paul Goude, Laziz Hamani, Daniel Jouanneau, François Lamy, Olivier Mauffrey, Michael Ochs Archives, Helmut Newton, Martine Parker (*Vue sur la Ville*), Guy Robert, Isabelle Reverseau (Roger-Viollet), Guy Robert, Paolo Roversi, Didier Roy, Susan Sone (Vernon Jolly), Michael Thompson, Axel Tilche, Cyril le Tourneur d'Ison and Nick Welsh.